No part of this book may be scanned, reproduced, or distributed in any form, printed or electronic, without the prior permission of the author or publisher

Copyright 2024-Yoandi Perez

We love to receive review from our customers. If you have the opportunity to write a review we would greatly appreciate it.

Thank you

Giganotosaurus

The head of a Giganotosaurus was 6 feet long!

Brachiosaurus

The Brachiosaurus lived more than 150 million years ago.

Plesiosaurus

The Plesiosaurus was a marine animal.

Xenoceratops

The mouth of a Xenoceratops was shaped like a turtle.

Stegosaurus

The brain of a Stegosaurus was the size of a walnut.

Oviraptor

The Oviraptor could lay up to 20 eggs at a time.

Yangchuanosaurus

The Yangchuanosaurus was as long as three car lengths.

Jobaria

The Jobaria was a herbivore that laid eggs.

Mosasaurus

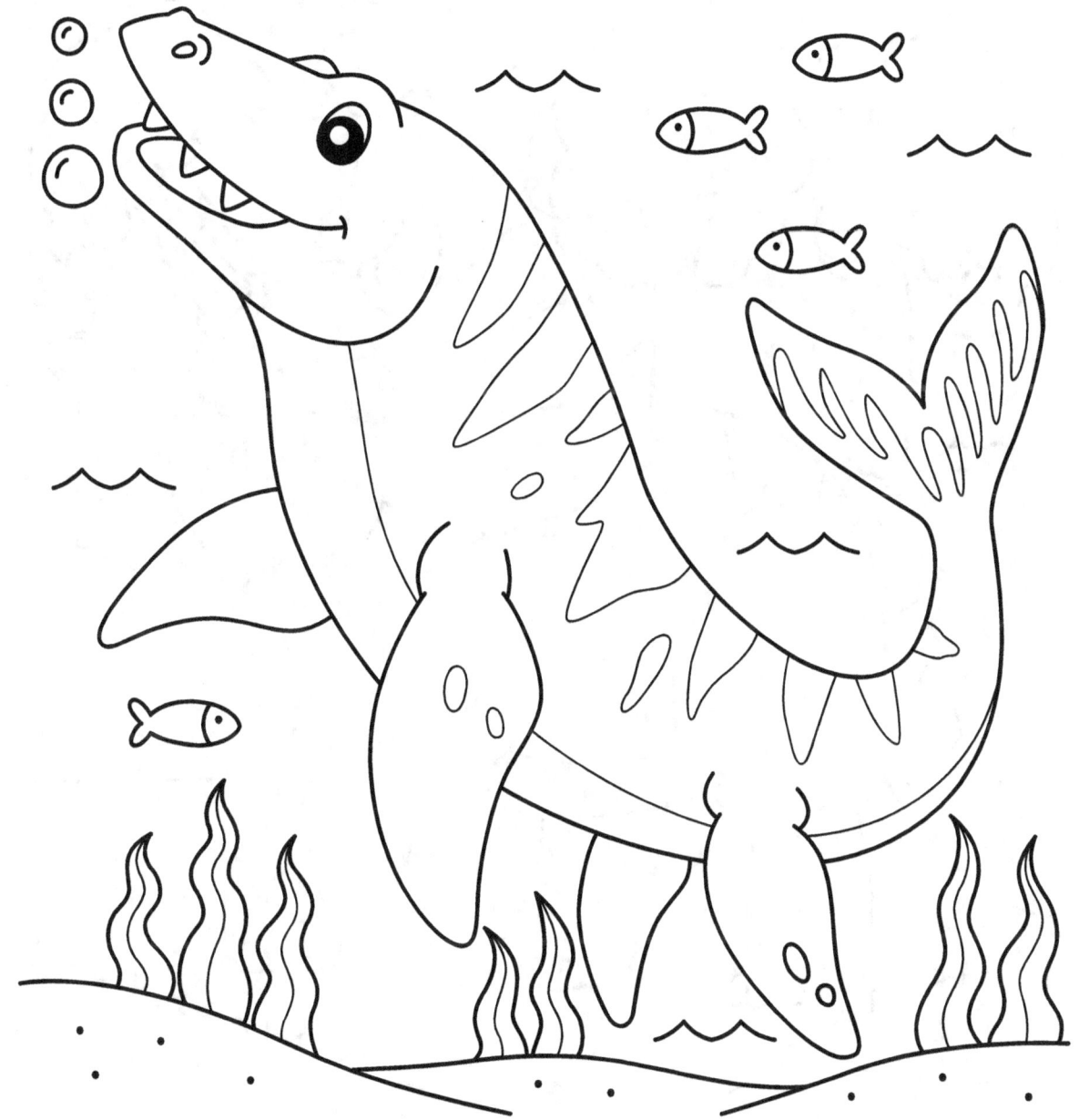

The Mosasaurus was found in oceans worldwide.

Triceratops

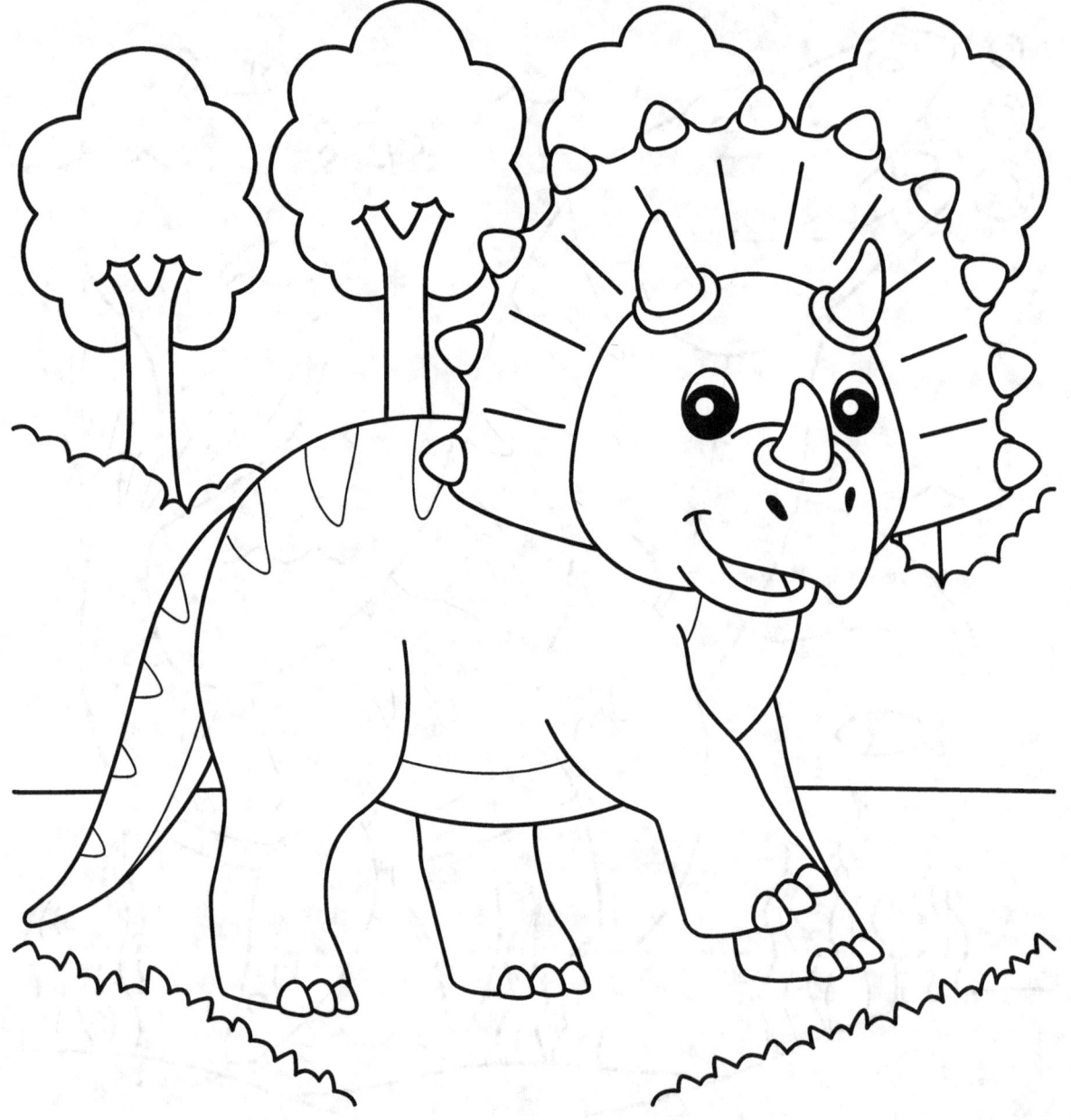

The mouth of a Triceratops acted like scissors.

Brontosaurus

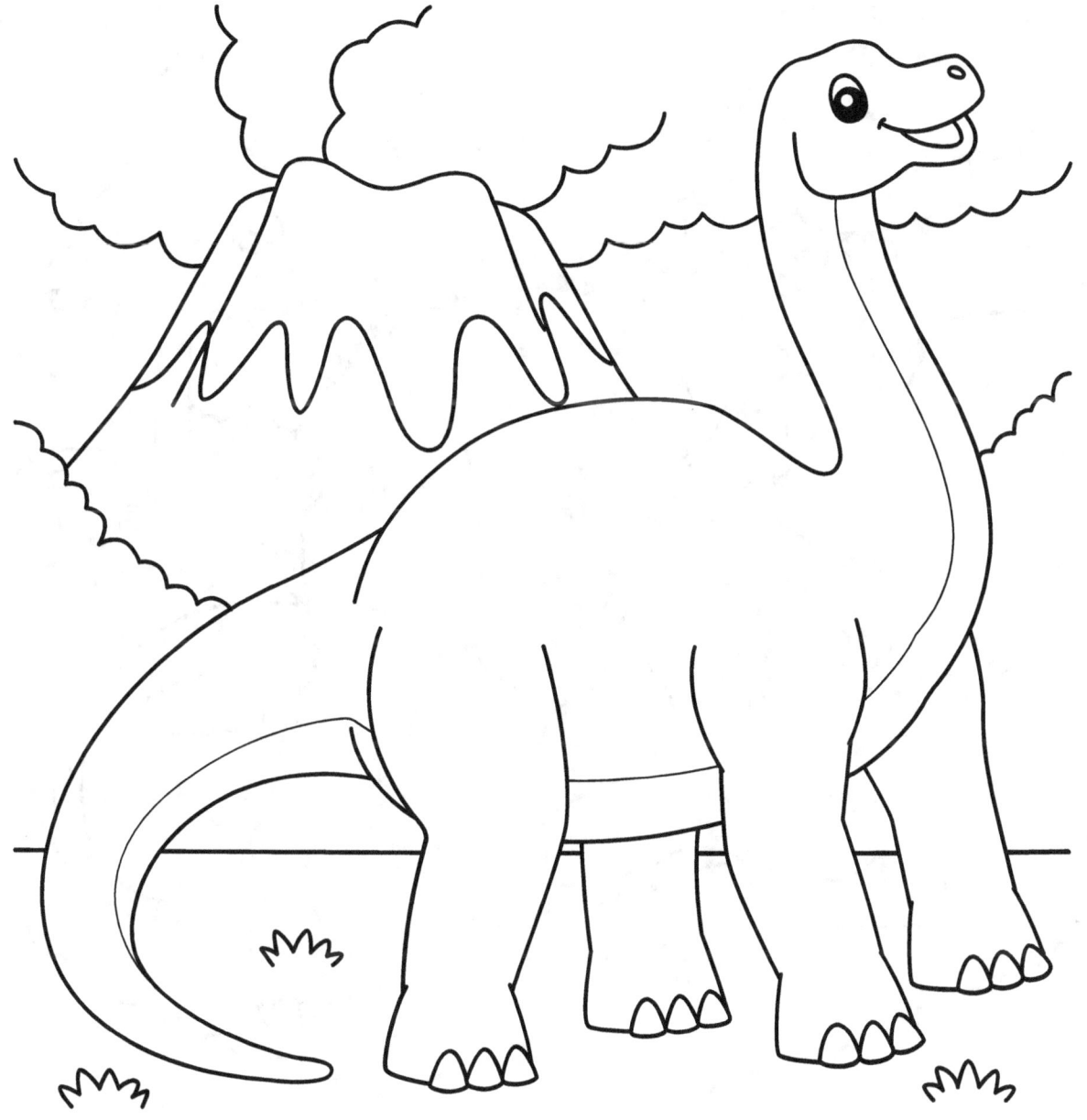

A Brontosaurus weighed about 33 tonnes.

Utahraptor

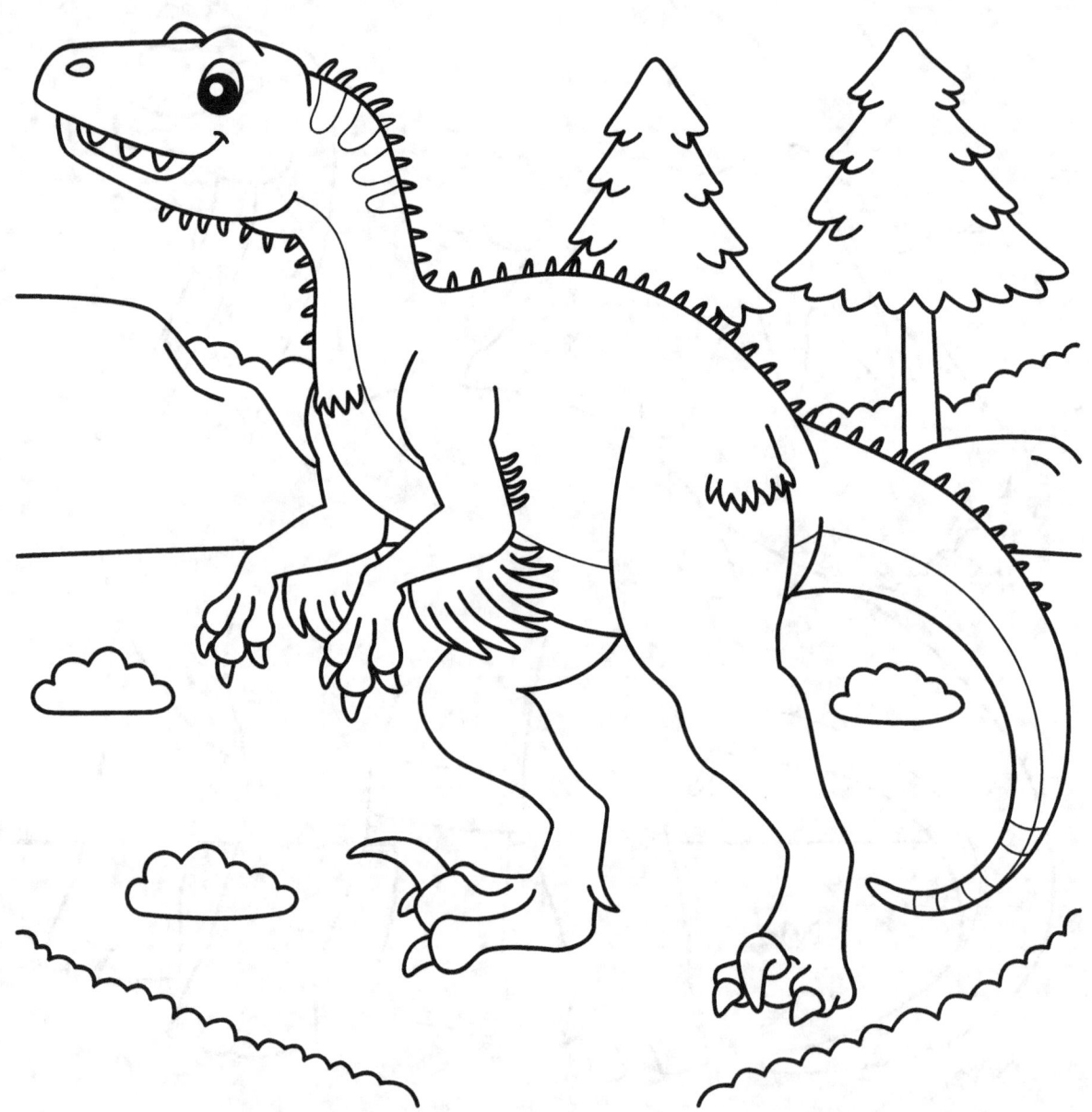

A Utahraptor could jump 15 feet high.

Velociraptor

A Velociraptor could run incredibly fast.

Lufengosaurus

The Lufengosaurus was a herbivore.

Diplodocus

Diplodocus means 'double beamed lizard'.

Tyrannosaurus Rex

Tyrannosaurus means 'tyrant lizard'.

Fukuiraptor

The Fukuiraptor lived about 136 million years ago.

Spinosaurus

The Spinosaurus was the largest land predator.

Pterodactyl

The Pterodactyl was a flying reptile.

Rajasaurus

The Rajasaurus was a carnivore that laid eggs.

Kentrosaurus

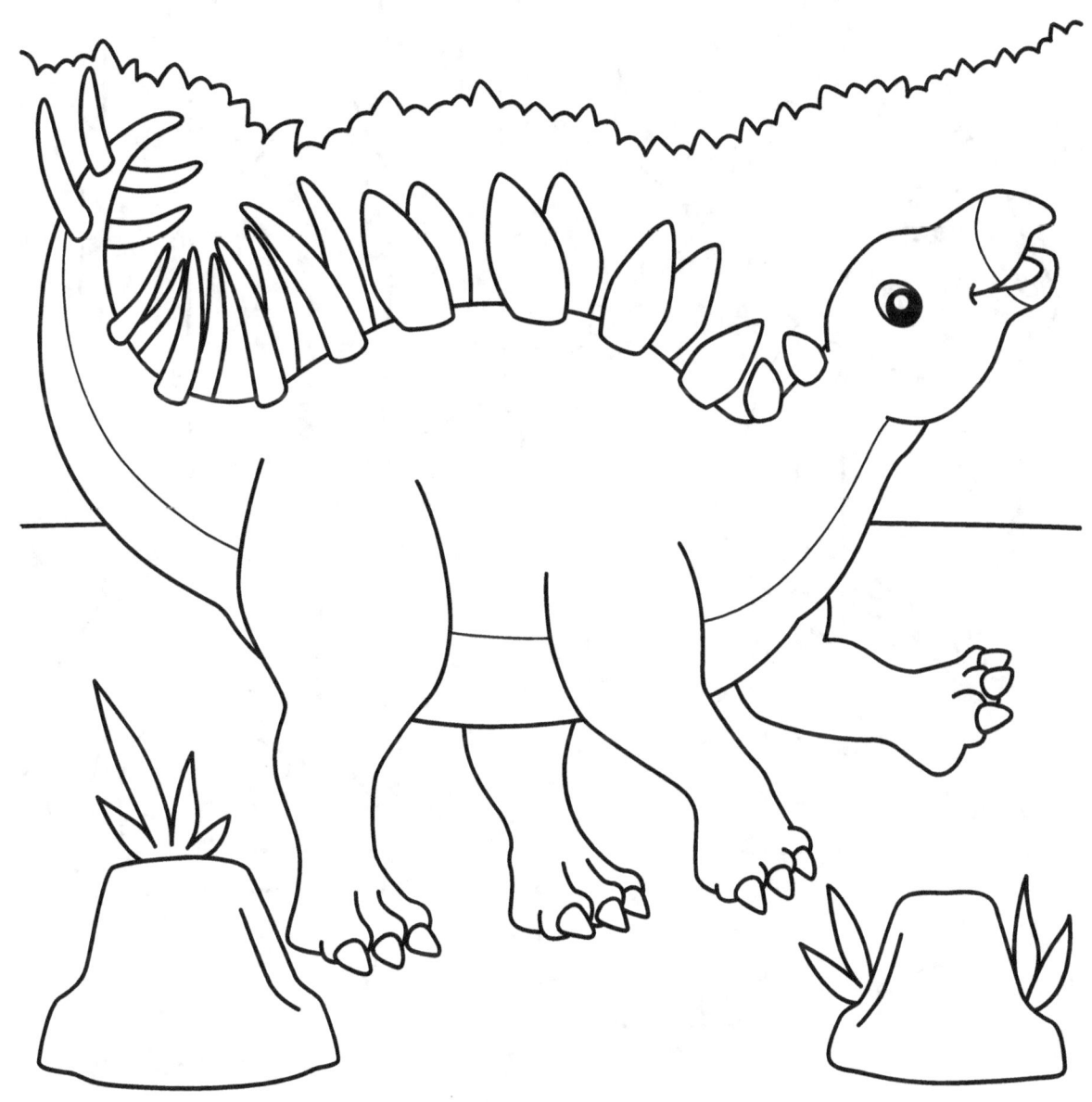

Kentrosaurus means
'spiked lizard'.

Carnotaurus

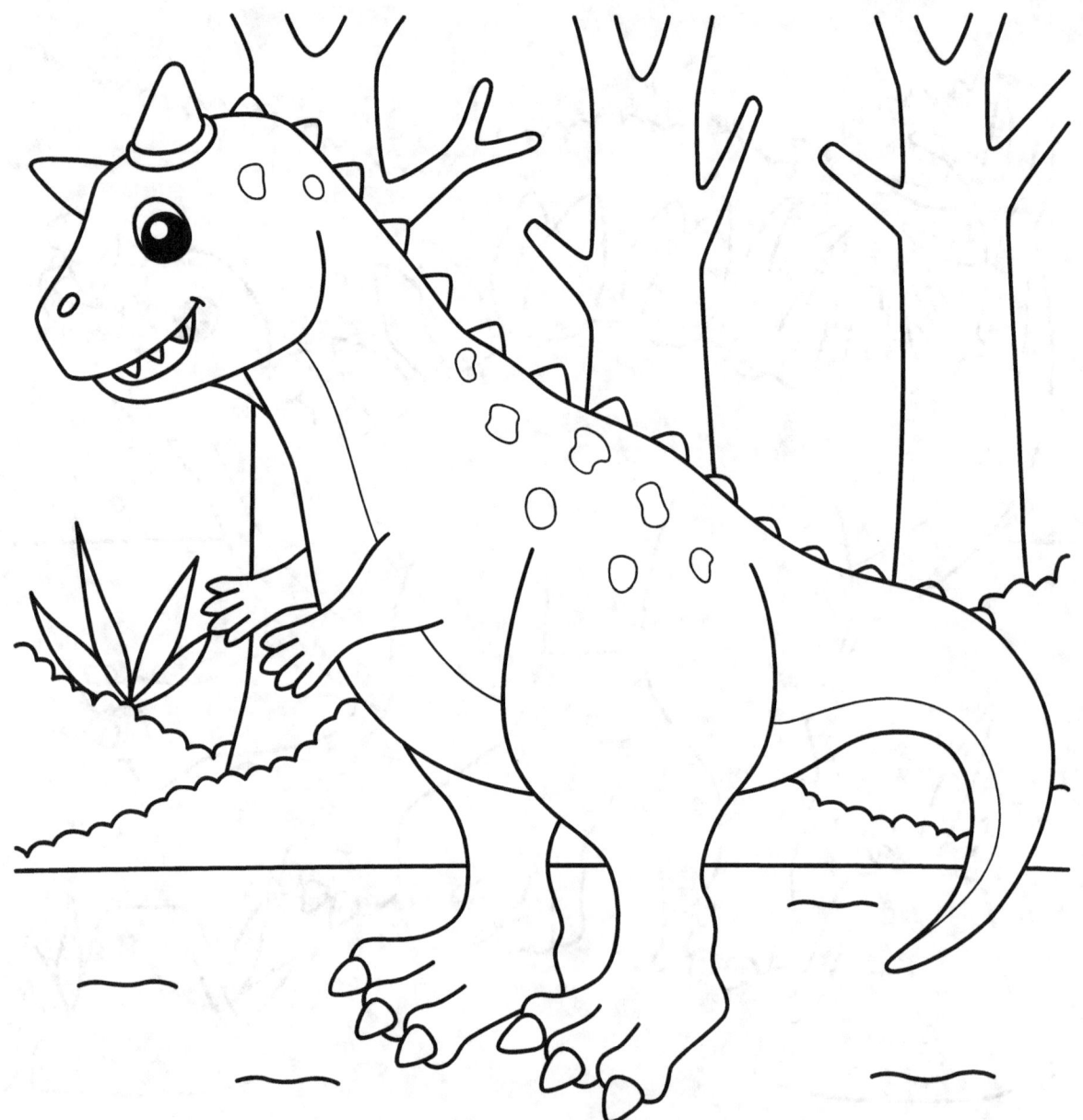

The Carnotaurus had tiny arms and could run fast.

Hesperosaurus

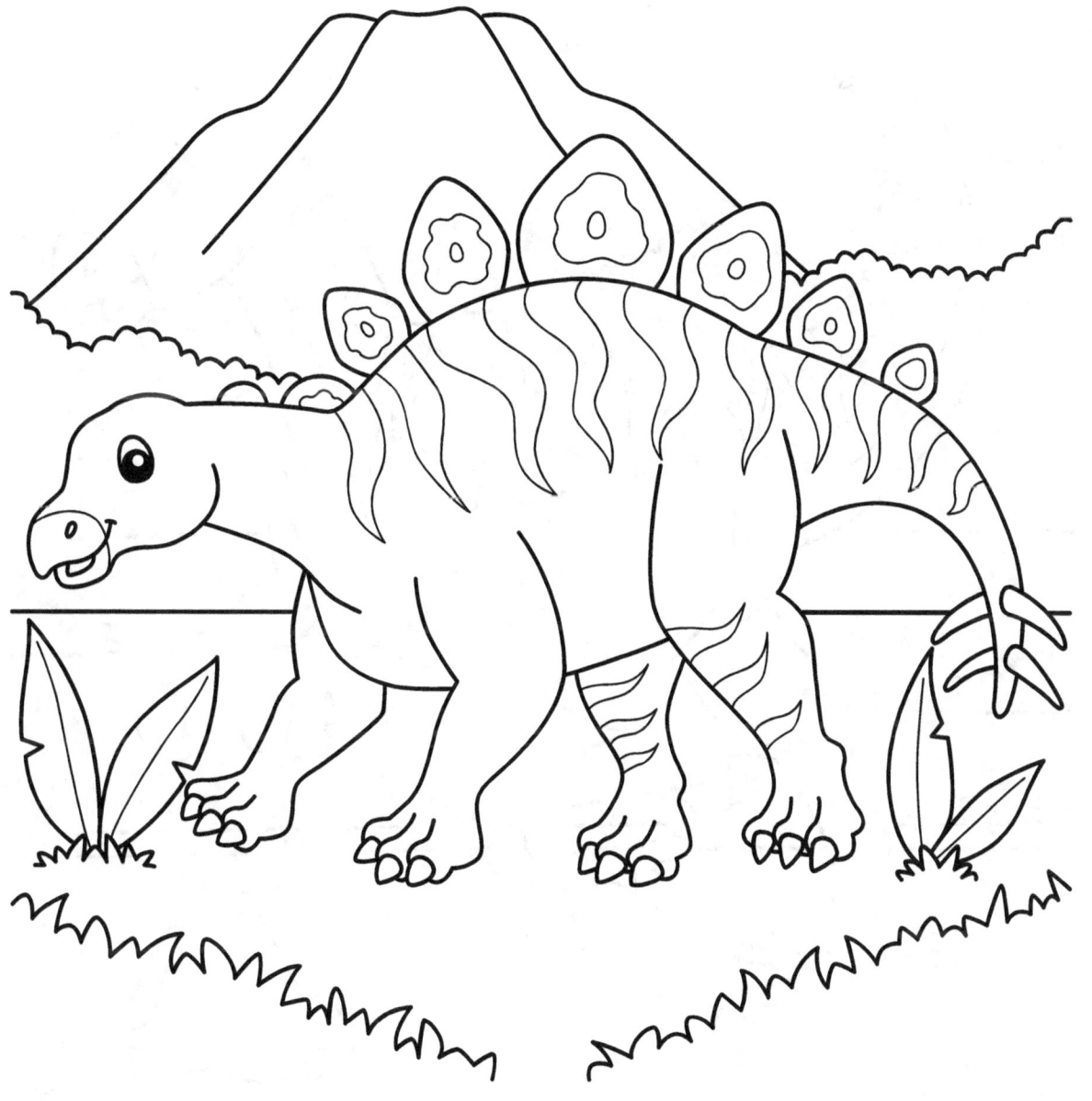

Hesperosaurus means 'western lizard'.

Qantassaurus

The Qantassaurus lived in Australia.

Iguanodon

The Iguanodon had a toothless beak.

Neuquensaurus

The Neuquensaurus moved using all four legs.

Zuniceratops

The Zuniceratops was a small herbivore.

Ankylosaurus

The Ankylosaurus had a very small brain.

Wannanosaurus

The Wannanosaurus lived about 70 million years ago.

www.ingramcontent.com/pod-product-compliance
Lightning Source LLC
Chambersburg PA
CBHW082242220526
45479CB00005B/1312